Songs to Kill a Wîhtikow

HAGIOS
PRESS

Songs to Kill a Wîhtikow

Neal McLeod

HAGIOS PRESS
Box 33024 Cathedral PO
Regina SK S4T 7X2

Library & Archives Canada Cataloguing in Publication

McLeod, Neal
 Songs to kill a wîhtikow / Neal McLeod.

Poems.
ISBN 0-9735567-6-5

 1. Cree Indians — Poetry. I. Title.
 PS8625.L458S65 2005 C811'.6 C2005-904980-4

Edited by Allan Safarik.
Designed and typeset by Donald Ward.
Cover design by Yves Noblet.
Cover artwork: wîhtikow II (2002) by Neal McLeod; photograph courtesy the University of Regina Photography Department.
Photographs of colour plates by Zach Hauser.
Text pages set in Futura and printed on 100 per cent post-consumer recycled paper.
Printed and bound in Canada.

The publishers gratefully acknowledge the assistance of the Saskatchewan Arts Board, The Canada Council for the Arts, and the Cultural Industries Development Fund (Saskatchewan Department of Culture, Youth & Recreation) in the production of this book.

CONTENTS

I call the darkness *wîhtikow*

Maya Angelou, in her autobiography, *I Know Why the Caged Bird Sings*, wrote that, "we survive in exact relationship to the dedication of our poets (including preachers, musicians and blues singers)." The Cree people have survived spiritually because of the persistence of our storytellers and poets who have kept our collective imagination alive.

The Old People, the poets, gave form to the moment of my birth. I remember when I was child my grandfather took me with him to Thunderchild — *kâ-pitihkonâhk* — in western Saskatchewan. To the best of my knowledge, *kâ-pitihkonâhk* got its name from *nipiy kâ-pitihkwêk*, which means "Sounding Lake." Sounding Lake in eastern Alberta is where Thunderchild's people entered into Treaty 6 in 1879. Thus, the name of the reserve means something like, "the land of the Sounding Lake people." Many of the Old People who gathered that day at Thunderchild were only a generation removed from the old way of life, and spoke stories thick with ancient echoes. They understood the power of language to carry a people and hold a place in the world.

The Old People from the land of the Sounding Lake people had threads of memory from the time of *mistahi-maskwa*, Big Bear. *piyêsiw-awâsis* (Thunderchild) had been close to *mistahi-maskwa*; so, too, was the father of my *mosôm*'s (grandfather) mentor, Jim Kâ-Nîpitêhtêw. Jim Kâ-Nîpitêhtêw's father had been alongside *mistahi-maskwa* during the time of the troubles in1885. *mistahi-maskwa* was an inspirational Cree visionary because he held the imagination

and collective memory of our people at a time when a great darkness, a metaphorical *wîhtikow*, fell on the land. *mistahi-maskwa* told old stories, lived old words, and did everything to ensure the survival of his people in an honourable way. Memories of him are threads of light that help guide us through the shadows which have dominated us for the past several generations. In his stories are songs that can kill *wîhtikowak*.

As a writer, I am also influenced by the fact that I am part of a generation that grew up speaking English as our first language. Yet, I also grew up at the time when our ceremonies were being revived. Many people my age had to go out of their way to learn Cree, to think about the meaning of words, and to try to transform the oral language into a written one.

I have written poetry all my life, and in my teens had several volumes of coiled, bound notebooks. Those old notebooks have long since passed, lost in many moves, but the process developed by writing them stays with me. When I was younger I always thought of the imagery of the words I wrote. I also thought of the words that would accompany my paintings. Because of the visually saturated nature of poetry, I have always preferred this genre of writing.

Some people say you should only write and paint what you dream. I have had dark dreams all my life, and engage them with my art. These dreams come from experience. They leave shreds of colour and sound, disorganized experience, and chaos. My poems help name this deep darkness and find rest in small moments of sound. I call the darkness *wîhtikow*.

wîhtikow consumes other beings. *wîhtikow* turns on others in its society, concerned only with its own well-being. The needs of the individual are pressed forward and the needs of the collective are suppressed. Some people believe that *wîhtikow* really exists. But, for me, *wîhtikow* is also a powerful metaphor for greed, the attempt to swallow the light from the sky of the world.

Stories of *wîhtikow* were especially common among the northern Cree. There was less food in the bush and people had to share in order to survive. The stories of the *wîhtikow* help keep social order and keep people from being greedy. In contemporary Cree,

wîhtikowipayi means, "to become a wîhtiko," and by metaphor means "to become greedy." Old stories find new places.

wîhtikow destroys social relations and upsets the order of things. Missionaries tried to scare people with these stories. They tried to make *wîhtikow* into the ultimate darkness — outside of ourselves — but forgot that *wîhtikow* dwells in all things, including Christianity. Many old Cree poets talked about the interconnection of good and evil, and the possibility that both exist in all things and situations. There is a bit of *wîhtikow* in all of us. Part of the process of poetry for me is to make sense of this darkness and to transform it.

wîhtikôhkân is different from *wîhtikow*. *wîhtikôhkân* is a contrary, or "a clown." The word literally means an "imitation *wîhtikow*." The *wîhtikôhkân* does things backwards, and is also associated with healing. One of my grandfathers was named *wîhtikôhkan*. He was my great-grandfather's (*kôkôcîs*) grandfather. *kôkôcîs* said that I resembled *wîhtikôhkan*, who was the brother of *kinosêw* and *mostos*. *kinosêw* was the main negotiator of Treaty 8. *wîhtikôhkan*, his brother, married a woman from Sandy Lake, and he raised my great-grandfather. The family line is my strongest link to the past.

My paintings and writing have always been interwoven with one another — not only my poetry but also my academic writing. Like my writing, my painting style is unorthodox, with many layers, shifting image and narrative throughout the process. I have both written about and painted the *wîhtikow*. I feel that by engaging this symbol through two forms of artistic expression, I am able to explore the symbolism more completely. Many of the paintings have words/poetic phrases in them. I have also included poems as artist statements at exhibitions.

Names mark memory and paths of experience. Names are like rivers that run deep in our souls. Words and names make us old in sound and give us a place, give us shreds of light, that help us give form to the moment of our birth. It is fitting to have a name like *wîhtikôhkân* behind me, and to invoke *wîhtikôhkân* to help to fight the darkness. In keeping with Cree protocol, I try to feed him as much as possible. My great-grandfather used to do this as well.

My poetry has been deeply influenced by participation in various poetry slams and at the Crow Hop Café. A band of friends with a

gypsy stage, urban nomads, set up shop wherever we could. The Crow Hop Café began five years ago, initiated by Tim Fontaine and me. It became a magnet for Aboriginal artists and writers, and quickly developed as a force of its own. It was here I learned the importance of the oral performance of poetry, and sometimes there was a need to change the lines slightly in order to fit the groove and flow of the room. I also learned the importance of humour in terms of being able to keep the attention of my audience.

Throughout the years, I have performed my poetry with musicians such as the Nancy Ray Guns and Robert Hoek. Sometimes these experiments were very successful, other times less so. When things went well, they were often electric.

I am not a traditional storyteller, but I have been profoundly influenced by tradition. The sound of an echo shifts over time, depending on the material that is holding the traces of sound. Just as an echo of a voice may have a slightly different sound as it bounces off a wall, the echo of a voice (or old voice echo) will also vary slightly from the original source. There is a narrative thread that links the various parts. My poems are part of a much bigger poem and process.

Neal McLeod
July, 2005

ACKNOWLEDGEMENTS
I would like to thank my father, Jeremiah McLeod, and my grandparents, Ida and John McLeod, and my great-grandfather, Peter Vandall (kôkôcîs,) for giving me a foundation in stories and words. I would like also like to thank my relative Maria Campbell who told me stories of my ancestors.

To my friends from the Crow Hop Café who helped create stories, songs, and tomfoolery with me: Robert Hoek, Keith Lee, Tommy Roussin, Preston LeCaine, and the late Marvin Francis.

I would like to thank my wife Christine and my children Allyson, Jordan, and Glen for their patience while I finished this book.

I would like to thank Arok Wolvengrey for helping me edit the Cree of this manuscript; any errors remaining are entirely mine.

Songs to Kill a Wîhtikow

MOVING OUT

restful days
my body lay still
my mind open
old impressions new again
warm water held me
prayers to the Creator
made the flames
subside into the blue
centered my mind
away from old habits
and things
I thought forward
able to dream again
no longer bound by pain
I felt myself fall from the sky
with words holding me
I miss old things
shadows that eat light
I feel uneasy
being peaceful
alone to rest

Neal McLeod

HOUSE OF IMMIGRANT DREAMS

I lay in dreams
my body like flower water
stripped by sun
I bought a ticket
crumpled and worn
barely bearing my destination
people gathered
I was chased
over rough terrain
I passed the old church
cracked white paint
graves with faded names
only depressions in the stones
marked the names
they said it was okay
they had memories
it was to be torn down
I stopped running
and felt my feet
turn to wings
I passed through
a corridor of light

WATER COVERED MY BODY

high banks
quick drop down
grass to water
breaks of light
give water form
pass through me
my fingers
river tips
hair heavy
dreaming blue
in my body
could not still
the flames
housed in body
home to
traced experience
marked flesh
sound bodied
my skin dry
took water
from tears
eyes hallowed
too dark
for reflections
I passed
to darkness
found my home
in dry cold
shadows

Neal McLeod

STARS HOLD NIGHT

everything thrown all over
light through window
resting on smooth places
floor holds light and feet

they came for me
determined in their steps
strong without hesitation
ground shock across
light pockets on floor

reminded me of pathways
through darkness opened
stars from skins
upon my body

braced against intrusion
leaned boards touched ceiling
called stars to my side
waiting for night's rush

ON WÎHTIKOW FLOOR

I lay in the remnants of thunder
a fugitive of spent moments
which had worn out their divinity

dreams, caged images
loosened every night
reliving the death of blue sky
the sky, blackened
upon the blue
thunderbirds hollowed
out the darkness
upon the water
to kill the *wîhtikow* snakes
who covered his body

he lay on the floor
hoped for thunder
the sickness in his stomach
was upon him
he lay in water
calm the bursting death
rage against
collapsing stillness
held the colours
of forgotten dawns
blackened suns
tore memory
from his lips
heart heavy
old like earth

Neal McLeod

LAST KISS

my lips are dry
I sit among people
strangers pass
through glass doorways
I hold back the tempest
water crashing through me
I want to make
my lips wet again
to make my body warm
I struggle to keep my soul
distance is like a *wîhtikow*
I stand at the edge of things
half of my vision
half of my hearing
my touch fails
feels only phantoms

PROVISIONS OF EARTH

into the night
I took
provisions of earth
to paint
cover my body
feel crimson tides
against the shores
of my dreams
strange creatures
and objects
upon the quiet edge
incursions of dawn
in my fingers
I reach for the air
hidden in deepest oceans
to fill my lungs
to chant songs
to kill *wîhtikow*

Neal McLeod

A WÎHTIKOW'S HOWL HOLDS THE NIGHT

rage marks the air
scars unheld in sorrow
in night without stars
wîhtikow
consumes his dreams

I saw his still body
unable to breathe
dug in heavy cover
he was unable to speak
the sky back

he lay at the edge of words
the great silence
his bed thick with death
he could not move

WHITE GIRL

she sucked words
from the marrow
of my bones
she was a tourist
white girl adventure
Goth girl safari
propped by her
heavy thick riding boots
ethnic sport fucking
she slummed it
maybe someday
she would write a novel
about me
how she saved me
from my penis
she summoned deviancy
and played with darkness
in her suburban temple
like a preacher
at those tent meetings
preaching that men were evil
I was not a curiosity
you know like at the fair
she would see in the tent
after she paid her way in
at least johns were honest
they paid for
what they wanted
she pretended
to buy love
with faded bills

Neal McLeod

PIMÂTISIWIN OHCI

simultaneous simulations
bring stars to my eyes
pimâtisiwin ohci, from life
new growth growing green
in widened spaces, widened reaches
feel the breath
of new universe against me
kâ-askîwikâpawit
standing earth
reach for the edge of sky
where your body
falls on me like rain
kâ-pawâtat nipiy
you are dreaming water

FROM CEMENT FLOORS

kisêyiniwak ê-wâsakâmapicik
aya, ânisko-âcimocik, ê-kistawêcik mîna
the old men sat in a circle
they connected through speaking, echoes
the old men spoke in chants
absorbed the quickened spaces
between awareness and infinity
they spoke sanctuaries into being
around me, their sounds rested

from cement floors
nimosôm, my grandfather came to this day
of old men speaking
from cement floors in jail cells
as he journeyed from our reserve
to the Gordon Residential school
taken by force, intimidated by Mountie guns he left
he was given a pair of moccasins to run with
but they caught him and took him away
he laid on cement floors
in days unfilled with dreams
he sat trying to remember the words
that gave form to his moment of birth

silenced land, crosses cut into earth
traces of thunder
whispering through fenced land
silent tongue, could not speak
the stripping of life and the peeling of souls
in chants of unknown prayers
he found no comfort in the suffering of Jesus

Neal McLeod

I remember old men speaking
at Thunderchild with *nimosôm*
and now, I think of those days
from the cement floors
to the circle of old men speaking
echo of generations
gave form to the moment of my birth

HOLES IN THE SKY

I sat there listening
as he bought me a Coke
he sucked back his whiskey
I listened to his words
and whistles as the band played
I realized that he was
opening up holes in the sky
for stories to come through

voices held forever in silence
through pulled tongues
stretched out in unending darkness
remorse too great
for any soul to hold
restless stillness waiting
emerge into movement
he told me of nights
of unforgettable silence
strangled, in quiet whispers

he told me that he came
to listen to the blues
that this was his church
he told me
there was an old man
who sat there in the sweat
he sang that song
like he was singing the blues

I thought of those
who lay under the weight
of the dying sun which held no thunder

Neal McLeod

the heaviness of collapsing sun
sweats through the blankets of stories
which slipped from them

the memories of days and prayers
informed and formed the solitude
held in that body
witnessed through his words
filled the spaces of the room

WÎHTIKOW SKIN

summoning broken moments
failing to fill the dry earth
which lay inside my flesh
absence like tumours consumed
the relics of my imagination
my lips craved the texture
of small divine gifts
wîhtikow teeth
could not find feast
in my flesh

WÎHTIKOW WANDERING

wîhtikow whispers
and pulls the light from sky
only cluttered cover, electric neon
makes my steps heavy
pass abandoned house
windows opened
no longer covered by glass
emptied of people
and stories
burned out black hollow
my body
has also known
the fire of *wîhtikow*
bingo caller gives false hope
white johns
circle the wagons of families
cops who drive brothers
to cold places
wîhtikow wanders
in the grey, concrete forest

TO KILL A WÎHTIKOW

my heart ripped
laid open
my flesh became
sun takes marrow
from my bone
mighty fallen dreams
laid to rest beside
sleeping without end
my heart becomes cold
like *wîhtikow*
all my life I searched
for a place to be born
where I could say
names of places
where my soul rested

from my ashes
I weep the morning
where I died
I saw sinew
stretched and dried
heavy breath of *wîhtikow*
upon my back
chases me through places
wîhtikow is poison
a virus always changing
never still

help me
touch the sky
I passed new earth
through my hands
my dry hands became wet
from your rivers
and *wîhtikow* drowned

Neal McLeod

WHEN I MET YOU

the first time
my eyes found you
surveyed past memory
placed you
in the field of my perceptions
in the seat of my awareness
long talking slendered by night
your eyes warmed
the falling snow
melted water on skin
orange candle light
can night space breathe
showing new path
I kiss your eye lids
in the morning
to let the sun
back into the sky

THE SKY FROM YOUR LIPS

I drink the sky from your lips
and offer prayers to the dawn to my birth
quickened water washes over me
the fragrance of your skin in heavy blue
peels away the night and water

in open waters my body prayed
the universe grows from your lips
new worlds form as I taste your thigh
in deep blue, I feel the broken sun stretch
my skin marked in scattered light
in the interior of celestial bodies
small crests of waves push against me
break upon my wet skin

I feel the sun through your breasts
which hold me in heavy blue
coiled around me, form me from stillness
surge of unbound presence, I feel the water move
opaque, with traces of your open mouth

Neal McLeod

STARS WOVEN INTO MY FLESH

I crave the smell
of emptied moments
as I lay inside
violence of burning time
in verses of sound
I look in the night
for your eyelids
where I want to play
a thousand kisses
and watch them
grow and blossom
as the sun approaches
my memories are riddles
I try to unravel
I cast my awareness
a fisherman's line
into the deep water
of my dreams
away from these moments
I feel a numbness in my lips
I wonder if I can illuminate
your passing
which is far too beautiful
and precious
to ever try and catch

KREUZBERG BLUE

I grieve the blue morning
empty arms, longing for presence
where I gather my deepest dreams
you cause oceans to storm in heavy blue
a perfect moment of arrival
glide of your blood under skin
and the way your fingers
plant promises of wilderness
upon me, the plants announce
and witness your descent upon my earth
wind from your hair shifts my dreams
opening still water from the mound
of your imagination
itê ê-mamâhtâwisiyahk
where we tap into the powers of the universe
I collapse in the blueness of your wet warmth
your eyes soft pull me in early Berlin morning
people begin to move into the streets
subways awake slow like horses back home
I crossed the sky morning
travel to places where stars are born

THE BREATH OF STARS

I opened my mouth
to let in the breath of stars
my body absorbed the light
that spanned the universe
forever returning
to new centres of entry
linger in spaces
that hold stellar gifts
exposed in flooded
permeated horizons
in the currents of emergence
in incessant mourning
of my body wakes
watch the breath of stars
pass from me back to eternity
kapê-yôskipayik
forever moving gently
twist in stellar wind
my body laments
their pilgrimage
through a flickering of presence
try to survey
without expectation
darkening of the spaces
within me
in the wake of departure
causes me to coil
in restless reflection
to face hidden starlight
an absence in morning
wrap the open spaces
of revelation
with transparent tapestries
that fail to transcend the gust

of anticipation and trepidation
tighten my body to feel
the vacuous dwelling
which time brings me
which my throat cannot swallow
taste my suspension
facing the stars
I wait for their return

Neal McLeod

NEW HOPE

blanket of warm water
at the edge of light
changes a *wîhtikow*'s heart
end of shrouded heaviness
my breathing eases
smooth rhythm
beginning of dreams
I rest in the words
that hold you

THE WORLD IS YOUR BODY

the world is a house
which holds your body
and contains the passing
of your light

I look for you in all things
in passing faces
in the secrets of trees
fanning of the wind
turns of branches
I search your form

I hear your voice
through sounded days
gathered around
intertwined and merged
they become full
world grows quiet
your hands open
the doors of the house
of your body
that lets out
your waited whispers

Neal McLeod

BESIDE YOU

I make peace
with the night
and surrender my dark
dreams to the moon

your warmth
holds night stillness
arms wake
sleeping sun
move day wind
through fingers

your lips
soft contoured edges
kiss my body electric
capturing
your divinity around my skin

CROW CROSS

body heavy wooden
black circling round
crow crowned head
claws extended, cutting
arms extended
wrapped into horizon
feet on hands
abrupt blood pecks
expired fright scarecrow
pulled off
hands fling free
legs fall hard
extend relaxed hand
ready legs
onto road
away from crows
remember tracks
upon skin
sing praises
black crow crying

Neal McLeod

SHRINKING SUN

I catch piece of sun shrinking
into orange horizon
on my hungry fingertips
that extend the green
growing earth to tired sky
earth gives me a place to dwell
body of another and my lips
to speak the universe into being
capsules of sound beautiful
in their fragile finitude
create the spaces between dawns
gather the torn pieces of sky
scattered into night
I felt naked in the middle of words
eyes closed, I dreamt
the songs of your body
night creatures taught me
the ceremonies of your lips
moon whispered slippery secrets
of the hiding flowers
which spring from spring air
plant dreams of wilderness in me
I see the dance
of night creatures melt
into the warmth of morning sun
from my closed hand, tight and moist
I release the light of stars
into the blanket of dawn's calling
wakening of morning bird song
your tongue loosened its own secrets
as my limbs lay deep

in your sounding water
like poems waiting to be born
from the eternal song
I could speak the bundled words
sounding through the latitudes
of your body

Neal McLeod

BENDING

wandering heart searches
something to hold day traces
memories of song and green fields
too heavy is my heart to push through the day
my heart has become old like earth

I ran through *wîhtikow* forest
and saw the sun
pass the open spaces
coming of light
that hid behind the imperfect cover
of forest ceiling

the sound of birds
answering each other in song
in slow vibrations
that stretched the colours
of new forming sky

I hear your voice
which moves me
through your words
and the sound
of earth skin opening

INDIAN SUMMER

the crisp wind of late autumn
passing of warm Berlin streets
reminds me of the end of Indian summer

old buildings, guardians of time
where I lay silent
beside her as she slept
our bodies translucent
breathing fire

I fan the flames
try to bring it back
through my breath
to bring back the words
like an old storyteller
my grandfather had a word for it
sîpi-kiskisiyân
"I stretch my memory"
to wrap my arms and legs around her
in the quiet places of night and day
stories fill us, make us, form us
I feel her story
run through my blood and marrow

Neal McLeod

WATCHING THE TRAINS PASS

ê-tahkiyowêk
a cold wind
I ache to live new days
sâpwâstan
wind blowing through
I plan to open my heart
train passing, whistle
filling the cold air, with sound
cigarette on my lip
taste of tobacco in my lungs
kîsikohk
in the sky
present, transformed
pîsim ê-pahkisimot, pahkisimotâhk
sun sets in the west
passing, passing in tracts of broken light
day exhausts *kâ-wâwâstêk*
shimmering light
becomes heavy
the night, my prison
I think new poems
waiting for her ears
to hear them

GYPSY HEART

I wander
a gypsy
to my own heart
in last crossing
of day star end

my mouth now a desert
forgetting my way to your water
in unclothed morning

stars woven into
the texture of my skin
I gathered flowers from
the fields of your touch
grow green, push upward
to greet day star

KÔKÔCÎS

plaid crumpled and folded
hidden patterns of fabric
clung around his arms
his brown, storied hands
with lines of memory
which marked events
stories, and words
reached for the chewing tobacco
which slid through the
spaces of his mouth
and with the taste of tobacco
through his tongue
which created words
moving through the room

I remember the open windows
and brown, wet roads
cars and trucks
would pull up
and people would fill the windows
with colours and movement

familiar faces and rhythms
I remember the sound of his voice
of his laugh
the eternal song
up through his mouth
added stories
and layers of memory
to the photographs
bringing old ones alive

I remember *kôkôcîs*
words came from him like water
formed from the shallow fog
of the early spring afternoon
the room held his voice
the voice of others
pushed through
the fold of eternity
were held in
his textured voice

kôkôcîs, kâ-kî-itiht
the one called *kôkôcîs*
was my living link
to eternity and relatives

Colour Plates

wîhtikow III, 2002

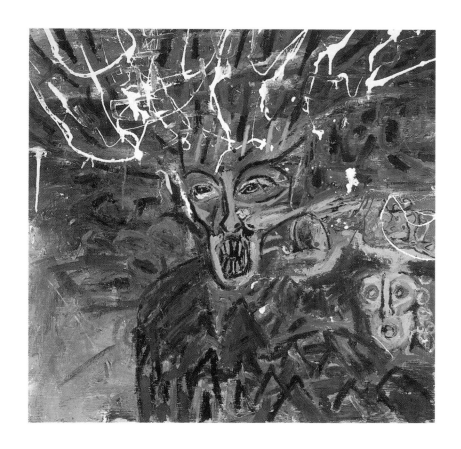

wîhtikow I (detail a), 2002

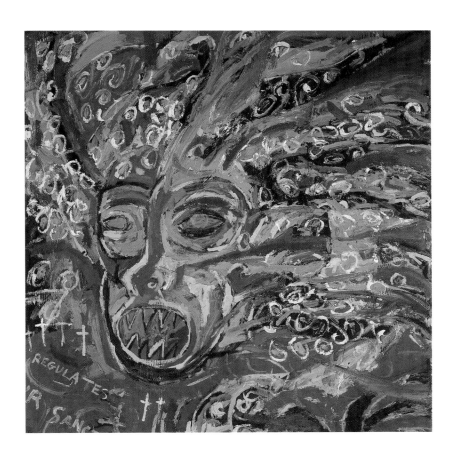

wîhtikow I (detail b), 2002

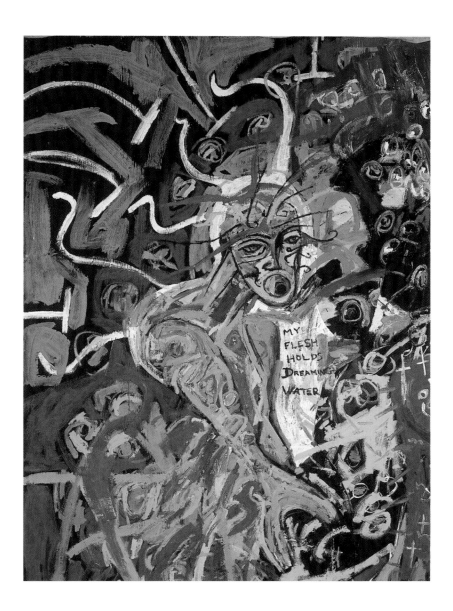

dreaming wîhtikow, 2002

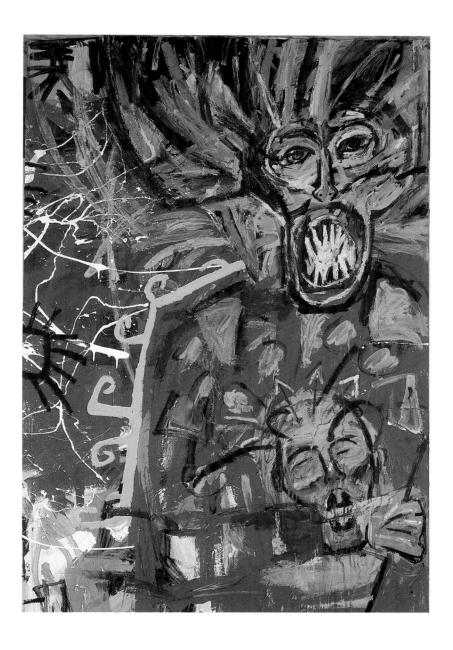

FIRE WALKS THE SKY

I dreamt last night of a woman
who held songs in clay vessels
sleeping thunderbirds wait
flickers until clay breaks
to release the water
upon parched ground

I wait for their call
kâ-kîtocik
thunder lifts the water
to the dry shrunken sky

McLeod, *mahkiyoc, nîkân-isi*
the foremost one, thunderbird
that is where our name comes from
sleeping beings in clay vessels

stories, and parts of stories
came back when I sat with *nicâpân*
she asked me to record the words
in her kitchen
floor worn patches
scattered throughout it

paths where she had walked
like her memory
maps of where she had been
she spoke water through the clay
and brought the thunderbird
back to the world

DREAMS OF CHANCE

last night
I had a dream
death of fall
below snow surface

a wolf came
bigger and faster
than the dog
dog was black
trying to shake
the wolf off its tail

the wolf mimicked
movements of the dog
always one step ahead
the dog did not have time
to look at *wîsahkêcâhk*

I was at the reserve
sitting in the room
a cat entered
I warned the old man
but to no avail
the cat tried to get the soup
I shot it twice
I wounded it
without injury

I was in the next room
three people
who I never had seen before
announced their presence
I realized the transformer
had changed again

Neal McLeod

HOLES IN SOUND

I recently went home
James Smith reserve
named after our first chief
they call it "the north"
where I bake my bannock now
my reserve is really
in the middle of Saskatchewan
on the edge of prairies and the bush
on the edge of English and Cree

we lost another two people
some stories fell from our conversations
Johnny Burns was one of them
who was a janitor at the school
pushed the mop
chatted in hallways
and spoke high Cree

when Johnny Burns
was younger
out in the bush
and one of his friends
played a trick on him
told him to put a blueberry up his nose
it was an old Cree charm

If it brought him luck
and sure to God
Ol' Johnny was an everyday guy
solid fellow, he was good people
they played old Cree songs
and Buck Owens' "Act Naturally"
at his funeral
followed by Cree Anglican hymns

with the beat of the drum
no one seemed to notice
the buffet of sound
Ol' Johnny must have
tapped his feet
dancing in the sky

Neal McLeod

NIMOSÔM ASINIY / MY GRANDFATHER ROCK

invocation to the breath to wind
disturbing the sleep of winter
in the cover of passing clothes
weathered stone
above the land like a sentinel
brown, in patches of grey through speckled black
in curved shadows hidden in heavy stillness
looked on open, green fields
where butterflies grow and die
through warm spring in greening sway
whispers of cool spring
through cracks of hidden sound
upon the prairie in open wind you rest
through my hair and lungs
I try to sing the eternity
of your stone body

INSTITUTIONALIZED

crumpled sheets, dark with shadows
where monsters preyed and he prayed
nurses, some with good intentions
walked the halls, keeping them
from falling completely
lithium, an anchor
held them
while they made
soft prayers to deaf angels
wîhtikowak crowded in
and ate the light

WÎHTIKOW

they spoke of the time
beings broke the stillness of water
retreating from the pollution
that rested on the skin of days
kî-mistâpâwêhisocik, they drowned themselves
and the water became still

I went to a place to rest
and lay in the remnants of thunder
I collapsed in ripped and dried hollow earth
a fugitive of spent moments
which had outgrown their divinity

the old ones spoke of how the beings dug into the earth,
kôtâwîwak
to retreat from the pollution on the skin of the earth
the old ones spoke of *wîhtikow*
who hunted dreamers, under thick, dark, coarse sun
took their prey in
like the wind of trains
draws us to the tracks

Ê-SÂH-SÂKINISKÊPAYIHOT

nicâpânipan kôkôcîs kî-nîhta-kistikânihkêw
my great-grandfather *kôkôcîs*
a successful farmer went
to *kistapinânihk*, Prince Albert
to get farm parts and other things
back in his day
a trip to Prince Albert was a big deal
not quite like Neil Armstrong's trip
or Diefenbaker's trek to Ottawa in 1957
but it was a big deal, big business

he always got all gussied up
hair heavy in Brylcreem,
suspenders holding up his pants
shiny shoes, and a shiny car
old fellas like old *kôkôcîs* wore suits
they were stylish, dandies
walked in style, proud as peacocks
marching the down the streets of Prince Albert
like Alexander through Babylon

one day, *nicâpân* was driving down the bridge
in the centre of Prince Albert
he didn't read English
so he couldn't really follow the signs
construction was going on
he kept driving down a lane
into oncoming traffic
he was happy to beat all hell
riding down the street in all of his regalia
catching the sun in the chrome of his car
the gloss of the metal radiating out
everything in slow motion

Neal McLeod

as he passed by the metal railing, time stood still
as he was crossing the bridge
like the fight scene of *The Matrix*
but *ê-kî-wâstinamâkot*, they were waving at him
at least that is what he thought
he smiled and waved back: *ê-sâh-sâkiniskêpayihot*
the way you would say in English
is he kept showing his hidden hand quickly

he waved, he thought they were just being friendly
but they were not friendly waves, but angry
my grandmother told him
to make the signals properly
my grandfather laughed, he said his wife
wanted him to make signals
just like old Indians
making sign language to beat all hell
ê-sâh-sâkiniskêpayihot
a whole story in one word

THE LAST GREAT HUNTING TRIP

this all happened in 1973 before my time
while I was alive but not old enough to go
my dad and uncles lived to hunt
I heard how one of my uncles covered ground
moved fast, but did not run

they gathered west of *kistapinânihk*
or Prince Albert as the cowboys say
drove his station wagon with wood paneling
seemed fitting
as we were really from the bush

smack dab in the middle of 70s swank
Indians went crazy, penned up on reserves
released and on the prowl on dance floors
and pool halls, with CCR blaring
seemed like every tagged blonde was some kind of revenge

they met at ol' Pete's place
or *kôkôcîs'* as the Indians say
he is my great granddad, *nicâpân*
lit cigarettes, filled the room with rough jokes
that would make even Andrew Dice Clay
blush like a schoolgirl
they piled into the station wagon
with wood paneling, spare fire wood I guess
if they ran out of their luck

they got out at the old Métis woman's house
they boys were thirsty
wanted to drink
Uncle Norman made her wheelchair dance
tracks digging into the floor
like trains across the parklands

Neal McLeod

tipping and turning
she smiled, like a kid at the fair
on the rollercoaster

the wheels would touch down
quiet filled room
everyone's smiles stopped
and joking laughter became philosophical
words ended undone
she motioned to the small box under the chair
and he opened it, grabbed the bottle
she smiled and motioned for him
to pour himself a drink
he drank, and started to make the chair dance again

later when they finally got to the bush
they made a camp fire, tents around it
shadows through light, people fumbling for things
old Uncle Robert was by the fire
laughing and drinking
Robert left bullets by the fire
and they went off, one bullet went through a tent
another just missed his head
they say he got into the groove
danced and boogied pow wow
just like an Indian John Travolta

the funny thing is that
on the last great hunting trip
there was not a lot of hunting
but that was the last time
my dad and all his uncles were together
I was too young to go
but I heard about it
Watergate, Welcome Back Kotter, disco came
and things changed

today they say that bush
is almost all chopped down
all of those hunters are gone, except for two
I have never gone hunting
but would like to go sometime
they say you ain't a real man till you kill a moose

INDIAN LOVE POEM

her skin was golden brown
like KFC chicken
she was fertile
had more eggs than a Hutterite
selling them to me
with a twist of her hips

her teeth were sharp
and pointed
perfect for birch bark biting
imagined the love poems
they could bite
into my skin

when I kissed her
I believed that I could
become chief
double dipping, skipping into meetings
my cell phone ringing
making me feel funny

she had 7 brothers
and a thousand male cousins
monogamy
was not a virtue but a necessity

SACRED MAN

"how do you say sunshine in Cree?"
his eyes squinted, he slicked up his braids with bear grease
and said, "you need to give me tobacco if you want to know"
there were lots of people like me who wanted to learn things
but culture became a commodity
something to trade to pawn, like old CCR records
sacred men held the words, and Fogerty's voice
and tried to make us mixed bloods urbanites insecure

but I didn't want any fast food culture
shake and bake shamanism
my dad and uncles all had short hair, and spoke good Cree
their words were not sacred
did not rant about the medicine wheel
they just laughed and told jokes

I hear sacred man has a job now
outside of a cigar store, doesn't move much
quite stoic, tip my headdress to him, every time I pass him
bugger never taught me a word of Cree

REZ DOGZ

we don't treat our rez dogz well
we kick them at the end of the day
make them eat scraps, KFC bones
and sometimes even make them into puppy stew
white people have old yeller
them rednecks cried when he got shot
but we just licked our lips

dog gone
"what's up dog?"
dog backwards god
bow wow, canine pow wow

the lonely echo
shallow, short whimpers
of all of the ghosts
rez dogz killed on rez roads

one time Old King was running
it was spring, all of the dogz on the prowl
like a chief's convention
running with their big bellies and small legs

Old King had just scored
cashed in his chips, spread his seed
dipped his wick then he passed by
in the open sky I heard the shot
that made the world stand still
his body retreated
and absorbed the shot
the old buck
bucked like a rodeo cowboy
only his horse was the air

traces of himself
you know horse means big dog in Cree

the bullet pierced his skull
blood dripped from it
he was shaken up
like bingo balls in the hall
but the old dog kept running
rez dogz never give up, he ran to the bush
and he hid out, took inventory
took stock of his stocky body

rez dogz shot up
our underpaid heroes
who are just happy if we don't eat them
I think King and all of his friends were happy
when they opened KFC on the reserve

rez dogz run, rez dogz boogie
they are always there
wagging their tails to beat all hell
like sparrows drumming
the air with their wings
always there, after bingo
greeting us with sloppy kisses
giving us hope
when all the *sôniyâw*
from the GST cheque was gone
always wagging their tails
giving stories to the roads

BANNOCK WAGON

a refuge, a safe place
it was a temple, a platform of desire
an altar of illusion
a reserve within a reserve

don't bother knockin'
when the van is rockin'
this metal horse, prestige maker
counting coup

Indian tacos split
on the front seat
fuzzy dice hold dreams
of Indian casinos
"wash me" scrawled on the back
by an unsure hand

a mattress spread out in the back
mack and his *iskwêw*
kicking back the beats
having their rez honeymoon

a picture of Conan
airbrushed on the side
the van was more than a vehicle
a transporter, a mover
creating dream portals
in the middle of pow wows

eight tracks, clicking, ticking
John Fogerty talking about a bad moon risin'
as *mosôm* gets out of his tent
greeting the night, checking his moonshine
curing under the full moon

GHETTO LOVE

Indians talk about their wounds
their scars, their hurts
playing their sorrows
in fucked up renditions of CCR
fuck that shit
I am alive on the prowl
and I want my ghetto love
I visit my honey brown
on the 20th of every month
I cast deep every time
like the old man in the sea
they might take our country
but dammit, they can't take our love
I am like junkie needing my fix
my love, wrapping my vein
getting ready to score.

the ghetto, the hood
the inner city
the place before the suburbs
and after the reservation
young men pass through the streets
black handkerchiefs
in the place of headdresses
gold chains in the place
of breast plates
g-notes instead of Cree notes
they trade their tribal lore
for gangster hustle

in one of my midnight creeps
I visit my ghetto booty
with her raven hair
her almond-shaped eyes

Neal McLeod

as tricky as Charlie Smoke
trying to tell tribal tales
my *iskwêw*, my gangster girlfriend
my bannock maker, my hip shaker
my love taster

kids banging on the door yelling
"what are you doing to our mommy?"
"why is mommy screaming?" their voices crazed
prophet like, as though the ice cream man
was hustling his wares
like Santa Claus
handing out presents

I went through tunnels
like a serpent waiting to spew my venom
like an American soldier
going through Viet Cong hideouts
or Baghdad streets
I find the end, but there is no booby trap
just pierced nipples
I bounce with a grin as wide
as the grand canyon
the kind of feeling you get
when you're on a tractor in spring
tilling and breaking fields
that awake from winter's cover
ass slapping, hips cracking
rap music, kids playing, cops siren
voodoo madness
I feel my ancestors pushing me
I could swear I saw all of them
salute me from the big teepee in the sky
Jesus died for our freedom
but we crucify ourselves in madness

ghetto love is dangerous, ghetto love is bad
never know when the father
of the kids is going to kick down the door
come home to roost
and shoot me down like a rez dog

ghetto love is crazy
you meet at offsale on Friday
and on Sunday you are shacked up
and by Monday you are calling her wife
on Tuesday you're pawning her goods
and on Wednesday her kids are calling you daddy
that's just how ghetto love goes

19 IN VENICE

I was 19 years old
it was 10 days before the Berlin Wall fell
I was completely oblivious
in the haze of my madness
I was not really worried
about the sociological, cosmological
epistemological present
it seemed I had mortgaged
my possibilities for merriment
with a lack of spiritual development

I was 19, young and crazy
and I half believed my antics
would bring about
the end of the world, apocalypse
worse than the greenhouse effect
I was 19 years old
full of hell, full of mischief
right from the reserve
I was in the middle of Venice, Italy
walking the streets
I was out of my element
a fish out of water
like Stockwell Day at a pow wow
yet somehow I pressed on
marching those streets
tracing the footsteps of Ernest Hemingway

I was happy, I was tickled pink
I was feeling randy
my heels were clicking in the air
I was checking my gear
making sure it was all there
strutting, strutting

strutting to beat all hell
like an emperor
there I was
a young buck, trying my luck
looking to fuck
in the streets of Venice
I found my way to a cozy little place
called the Crazy Horse Café
thought I would try to find a target
to unleash my expectations
and trepidations upon
someone that I could feel
some gratification
through my gravitation of
my movements and words
if I could go back there I would
but I can't cause I am here with you
at the Crow Hop Café
telling you this little story

the room was full of slick Italians
I swear to god, half of them
were probably in the mafia
they were well-groomed
little poodles
all cute, all done up
smoking, they were talking
they were joking
here I was
a simple little guy
from a simple little place

let me tell you I was struttin'
trying to move through the room
trying to find my groove, my rhythm
I was trying to remember

the great stories
of my father and uncles
their stories
of exploitations and sexual conquest
and physical endurance
let me tell you, at the Crazy Horse Café
I saw all of these pictures of old Indians

those guys had mojo
they were full of Buddha
the force, *mamâhtâwisin*
whatever you want to call it
in whatever language
let me just tell you
those boys were on top of their game

now the problem was
I had no Obi Wan Kenobi
to guide me through these moments
hell, I didn't even have
a dream helper
all I had was my courage
and my misdirected
intention and jubilations
I sat at the bar
ordered a double shot of scotch
lit my Marlboro
gave it a bit of a tug
I was leaning against the table
trying my best James Dean
I had seen in the movies

I was making idols out of moments
I was deifying my fantasies
I pulled myself back
to the world through my cigarette

let me tell you something
I wouldn't recommend it
but I was doing it anyway
the effects of the Moroccan hash
were starting to kick in
you can't blame me
I was just from the reserve
nothing like Moroccan hash
when you are 19
walking the streets of Venice
let me tell you
that is not Kinistino Saskatchewan

I started flying, I was sitting at the bar
I saw Jesus, Gandhi, Napoleon
other luminaries of past days
I heard the beat
of tribal dancers and tribal singers
moving against me
tingling my flesh, my loins swelled
my word gelled

let me tell you
I began my inter-galactic flight
with the woman who sat beside me
telling my secrets
I even told her my Indian name
and everything I thought
would pull her chain

I spoke everything
and spoke nothing
don't get me wrong
I am not trying
to get Zen on your ass
or trying to fuck you up

Neal McLeod

but I was an intergalactic traveler
going past Polaris and other stars
it was a great night
great night indeed
a man has got to be careful
with hash though
you can see things
that are not really there
turned out the whole time
I was talking to a chair
a phantom
the whole fucking time
I was talking to a chair
but it really didn't matter
cause I was a Cree boy
in the streets of Venice

SAULTEAUX BILLY JACK

I walked into the half-lit room
chattering voices
merged together in a low dim hum
clank of metal
people enjoyed their meals cafeteria style
metal cutlery shuffling on the trays
I heard people tell stories
and laughing at stories not quite told
I saw him again, the man of legends
the man behind the stories
some called him John
others called him Jack
that is what they called him
back home

in the city
people know of his exploits
his adventures, his deeds and his words
women nervously smiled
when they heard his name
men either laughed or frowned
depending on whether
he was enemy or friend

"I was so tired" he said
and his friends laughed
perhaps his words lifted them
out of the tiredness that day
had inflicted upon them
and their imaginations
Jack, the Anishinabe Billy Jack
bent time and space like a shaman

Neal McLeod

he pushed words and actions
into new shapes like an artist
making sculptures of clay
I knew that this man
touching the edges of creations
with his stories
words allowed him to witness
the divinity of all that was
and would be

he spoke of how
he fought off five bouncers
and how the new bouncers shook
shivered like nervous schoolgirls
whenever they heard his name
"I am so tired" he said
he spoke of the fists
and the black eyes
and bruises, about the warnings
that he had given them
about just wanting to be left alone
that he did not want any trouble

but as I left the place
I looked up into the open sky
the sky, half filled with clouds
lazily moving through the air and space
and I knew that the stories
of this Anishinabe Billy Jack
could not be forgotten
he was the man
who had looked straight
in the face of colonialism and won

from a small Anishinabe reserve
north of Winnipeg
I smiled and threw down
the remains of my cigarette
on the pavement
I left a track to show
that I had been there
to show that there was a man
who know the stories
of the Anishinabe Billy Jack

CROW HOP

west nile rides crow wings
wonder if it is safe to hop
at the crow hop
madmen proclaiming half-truth gospels
"Damn communists! damn half-breeds! damn crow hop!"
itwêw the king of the queen city

swinging scoundrels
saddled up
check their gear
beckon lost gods and idols
drowned in 70s funk
twitching itch
streams of sounds
fractured by laughs and beats
poets, midnight prophets
finding solidarity
preaching the gospels of insanity
indulgence and madness
light saturated
shadowing musicians and poets
getting down, down,
down below the optic nerve
with the smell of *kîskwêyâpasikan*
in the air
giving us messages
without expectations

ASKIY OHCI

I think about finitude and death
the way moments
sometimes fractured
stories try to stretch the width of the sky
deepen the depth of the earth, *askiy*

I have often thought about
the retreat of the buffalo from the land
long steel lines steal the sanctity of the earth
ê-mistâpâwêhisocik, kôtâwîwak
trains train the beings to become
traces of light, shadows
in a land polluted by new presence

PÎKAHIN OKOSISA

cikâstêpayihcikan, shadow maker
television, brings the world home
in shadows and flickers
cikâstêpêsin, another kind of shadow
shadow on the water, he was a chief
a leader, an okimâw
lived with his people near Birch Hills

his people were dispersed
and taken from the land
like the buffalo
after the time of the troubles
ê-kî-mâyahkamikahk, where it went wrong
they came to camp
at James Smith Reserve
a brother-in-law of the chief
pîkahin okosisa
spoke the shadows
out of the water

pîkahin okosisa was told things
by the powers, *ê-kî-wîhtamâkowisit*
he passed through time
merged the future into the present

dream speak, organic thought and words
everything, all things
kahkiyaw kîkway, meshed into one story
one person, like a rope bending
into itself to one point

pîkahin okosisa
spoke water into being
took the stars from water

placed them in words
when he moved water
my people were trapped
confined like shadows
that waited for the freedom of light

DRAW SHADOWS FROM THE SUN

treaties settled people
reserves made still
movements of wind
people scattered
made a community of people

people still traveled in the land
land, *askiy*, traces names
draws shadows from the sun
light of land
clothed people
with *maskihkiy*, medicine

TRIBUTE PASSING POET

smoke blue paths
up room airways
rich oil paint smell
green tea
down my throat
loosened stories

old recorder
plays poet voice
become new
in moments
old friend echo
gather together
friends form whisper
words become
warm again
resting in mouths

Neal McLeod

NEW LIFE

kisses pull edges
of deep oceans
watched her sleep
lips perfectly formed
opened on the top
the ends of trees
touched sky spaces
empty water
of my heart
became a river
old trees grew wet
her long
brown fingers
bring the orange of
morning sun
to me

KÔTÂWÎWAK / INTO THE GROUND

lived in shadows
waiting for something
to touch away the night
trees, plants
merged through the roots
pulled the soil
from the surface
of the earth
down to our bodies,
buffalo entered into the earth
we surrounded
our bodies with earth
plants to grow
pictured those beings
inside earth
getting larger
small humans
waiting to walk
she was earth
to hold new body
new voice
my scarred flesh reborn

Neal McLeod

DYING EARTH

I lost the sun
to the point of the horizon
tried to hide from *wîhtikow*
lakes dried in my approach
my cracking lips thirsted
my blistered feet
in the water of dying rivers
I traced the places
where rivers had been
gathered the remaining bits
of warmth in my body
need a place to rest
some water to cool my body
to cool my soul
water to hold
scattered pieces of days
I try to run to in my dreams

MANITOWÊW

names hold old land echoes
one name
was almighty voice, *manitowêw*
a voice that could not be silenced
from one arrow reserve
but passed by my reserve
in his travel through light

Charlie Burns told me
manitowêw killed a cow
he was put in jail
escaped as he hid
in his grandmother's house
a hole in the floor

to know the light
you have to pass
through the darkness
to know the words
you have to name the silence

they could not restrain
the sound of voice and name
not keep the voice
Charlie told me
old Sam police found them
a hill, where they had surrounded him
he warned Sam to run
he was going to kill his friends
the red coats
killed eight there

Neal McLeod

WÎHTIKOW FARMERS

beneath the hymns
crazed hollers for Jesus
rows of church pews
pressured him to be a man
and break the field
give order through crosses
they looked to the sky for Jesus

wîhtikow farmers
ploughing fields
young boy
mind full of Jesus Christ
and the second coming
"I am the way to life"
tractor slithered
through the fields
like snakes through dirt

digging earth
from wind's breath
skies, open blue
the boy's mind
waiting for the lord of the earth
to come and shed light
on curled snake's bodies
devotion and fervour
"praise be God!"
feet moving
bringing in the light
and shadows for
wîhtikow to pass through
snakes in the fields
of my skin

SUBURBAN CASTRATION

suburban regularity
appointments, day planning
Safeway savings cards
bank statements, phone bills
soccer games, screaming parents
electronic withdrawals
my soul being overdrawn
I signed up
for white awareness classes
learn the importance of monogamy
and other suburban virtues
madness regulated
everyone kept their stick on the ice
sex twice a week
double mortgage payments
all the houses look the same
all the stories sound the same
"24 hour martinizing"
"we do it all for you"
words are manufactured
desecrate creation in cunning desolation
suits neuter the wildman
I looked more like a Mormon
than a buffalo hunter
with my accent
I sounded more
like an Indian Agent
than an Indian orator

Neal McLeod

WÎHTIKOW SUN

I remember the open summer sun
field of tall, grey buildings
stretched to the edges of clouds
yellow in whispering fields
butterflies through green
bright upon the day
white in my eyes
from sun
brought and took the day
heat in the fields, yellow scattered
sky turned black
no warmth on my tongue
felt her breathe
eat the sun from the sky
her hands pulled
pieces of me
to feed her
when the sun
would not suffice

SHADOWS

I call the dawn in hidden night
darkness cools the sun's calling
plants shrink and wait curled
coiled, recluse in remnants
shadows in dance
in the absence of light
creatures move through spaces
make noise with falling feet
on cement floors
long stringy fingers
feel the spaces of my dreams

Neal McLeod

PRESENCE

your body, dreaming earth
your lips, dreaming water
your eyes, dreaming sky
entwined our bodies emerge in new creations
we extend our words in divinity
as I collapse in you watery earth
your skin
soaks into me
your softness
my skin craves the light of dawn
upon your body
I follow you through morning

FASCINATION WANDERING

I lay in fields
without speech
my body a house
shell of my life
soft by drying
a skin of light
leave loose pieces
of woven remembrances
with no sound

the wind from your body
brings back the clouds
which hold water
which fall from the sky
through your lips
and loosen the cracks
of my flesh
into my body
as your body a new skin
holds the names of tomorrow

once you open the words
cannot be closed
words grow
like water droplets forming
with more words
there are more spaces
which give me places for
my feet to travel upon

Neal McLeod

YOU TAUGHT ME THE SKY

top of my dreams
all of things
passed through my sight
all the days that I have lived
high above things
at the end of a journey
my head touched the clouds
my arms were the sky
I touched the sky with my lips
felt the clouds with my hands
and flew to your body
as my arms became wings

THE CHURCH

wîhtikôhkân sat in neat pews
preacher speaking the news
nervous children shifting
wîhtikôhkân fake *wîhtikow*
arched areas of light
crosses, pictures of old saints
"Hell", "Sin" in pitched voices
fills the room with sound
newspaper of the day
good news makes old storyteller wonder
smoke from small hand, pipe
fills the converging ceiling
sâh-sîhcisiwak, he said
making sense of making lies
he rubbed his grey hat

askiy ohci: from the earth

aya, ânisko-âcimocik ê-kistawêcik mîna: they connected through speaking; echoes

cikâstêpayihcikan: television; shadow maker

cikâstêpêsin: shadow on the water

ê-kî-mâyahkamikahk: where it went wrong

ê-kî-wâstinamâkot: they were waving at him

ê-kî-wîhtamâkowisit: was told things by the powers

ê-tahkiyowêk: a cold wind

ê-mistâpâwêhisocik: they drown themselves

ê-sâh-sâkiniskêpayihot: he kept showing his hidden hand quickly

itê ê-mamâhtâwisiyahk: where we tap into the powers of the universe

itwêw: he says

kahkiyaw kîkway: everything

kapê-yôskipayik: forever moving gently

kâ-askîwikâpawit: standing earth

kâ-kî-itiht: the one called

kâ-kitocik: they call out

kâ-pawâtat nipiy: dreaming water

kâ-pitihkonâhk: Thunderchild Reserve

kâ-wâwâstêk: shimmering light

kî-: denotes past tense in Cree.

kinosêw: The Fish; main negotiator for Treaty Eight

kisêyiniwak ê-wâsakâmapicik: Old Men sat in a circle

kistapinânihk: Prince Albert

kîsikohk: in the sky

kîskwêyâpasikan: marijuana

kôkôcîs: my great-grandfather

kôtâwîwak: the beings dug into the earth

mahkiyoc: the Big One; original name in Cree of "McLeod"

mamâhtâwisin: the life-force

manitowêw: Almighty Voice

maskihkiy: medicine

mostos: brother of *kinosêw* and *wîhtikôhkan*

nicâpân: my great-grandfather

nipiy kâ-pitihkwêk: Sounding Lake

nîkân-isi: other name of *mahkiyoc*; the foremost one; Thunderbird

mistahi-maskwa: Big Bear

nicâpânipan kôkôcîs kî-nihtâ-kistikânihkêw: my great-grandfather kôkôcîs a successful farmer

nimosôm: my grandfather

nimosôm asiniy: my grandfather rock

okimâw: chief; leader

pimâtisiwin ohci: from life

piyêsiw-awâsis: Thunderchild

pîkahin okosisa: the son of *pîkahin* (*pîkahi* to stir a liquid)

pîsim ê-pahkisimot, pahkisimotâhk: sun sets in the west

sâh-sîhcisiwak: to sit tightly (e.g. crowded sitting)

sâpwâstan: wind blowing through

sîpi-kiskisiyân: I stretch my memory

sôniyâw: money

wîhtikow: a being who consumes other beings, greedy, a vampire

wîhtikowipayi: to become a wîhtikow; to become greedy

wîhtikôhkân: fake/artificial wîhtikow; clown; name of my grandfather

wîsahkêcâhk: the eldest brother; the transformer

Poet, visual artist, film-maker, and academic,
Neal McLeod holds a PhD in Indigenous Studies
and teaches at the First Nations University of
Canada in Regina. He studied art at the *Umeå
Konsthögskola* in Sweden and has exhibited his
unique and powerful paintings in galleries
throughout Canada. He is a founding member of
the Crow Hop Café, a showcase for Aboriginal
talent, and currently leads the comedy troupe,
the Bionic Bannock Boys. His low-budget feature
film, *A Man Called Horst*, was screened in Berlin
and is becoming an underground classic. *Songs
to Kill a Wîhtikow* is his first book.